NEW YORK

W. W. Norton & Company • New York • London

NEW YORK

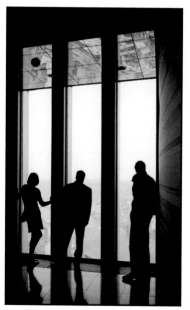

TAMAS REVESZ

First Edition

Editor **Jim Mairs**

Translator **Ivan Sanders**

Book design Tamas Revesz - **EcoVision** LLC

Prepress in USA **EcoVision** LLC

Printed in Hungary by **Novoprint Rt.**

The text of this book is composed in ITC Galliard

Publisher **W. W. Norton & Company, Inc.,** 500 Fifth Avenue, New York, NY 10010

W. W. Norton & Company Ltd., 10 Coptic Street, London WC1A 1PU

www.wwnorton.com

ISBN 0-393-05023-8

tamas revesz
NEW YORK

The early-morning magic show across the river lasts but for a few moments. A waking dream. Through the sheer curtain the silhouette of the city turns into a cubist composition, the shimmering, uniform slabs interrupted by the Gothic Batman-hood of Riverside Church. A gray-blue Hudson fades into my balcony; the river seems to flow right under me.

Just as one turns a fine morsel of food in one's mouth, savoring every subtle, delectable flavor, so I keep looking, with eyes closed, at the imprint—a panorama of New York framed by my window.

The soundtrack is the periodic hum of the elevator, the even drone of air conditioners, and water gushing from the tap as though liberated, and then with a rattle sucked down the drain.

How different and yet similar was the picture I woke up to each morning not that long ago. From our home on Rose Hill, the city of Budapest, like a bashful girl reluctant to reveal her charms, uncovered itself slowly, suggestively

—a bit of the Castle district and, rolling along underneath, the Danube. Up on the hill, in the early morning quiet, even a birdcall sounded like a piercing cry.

New York is not bashful, it hides nothing, it offers itself to you: Here I am. Want me? Buy me. Its openness is a little frightening.

The suitor's heart begins to race, it pounds with excitement and reverberates in his eardrums as the meeting nears. This is what I wanted, yet I find myself muttering: Slow down, we hardly know each other. I am from the Old World, I am not used to this much vehemence.

A grotesque image: I see myself as the newcomer, an immigrant knight trotting down Fifth Avenue on my trusty steed, a veteran of many European battlefields. "Won't it be better if you stay peacefully at home, and don't go off round the world looking for better bread than is made of wheat, without first reflecting that many go for wool and come back empty handed?" Cervantes's words from Don Quixote come back to me, but I don't let them sink in; a

defensive impulse squelches my doubts.

I cannot say whether it was the challenge of it or perhaps a midlife crisis that made me cross the ocean with my family and, leaving behind a stable existence, plunge into the unknown, start life anew.

The familiar Mediterranean brown-red stucco is nowhere to be seen. And the East Central European knack for regulations is supplanted here by another principle: Everything not prohibited is allowed. The liberating dynamic of diversity predominates. But to the ear, and spirit, accustomed to rhymed verse, a regular beat, the hubbub is a bit much. It takes a while to pick up the wilder rhythm.

It's as if I had a kaleidoscopic view of the city. It's like a huge cell, seen through a microscope; it throbs, changes overnight, absorbing everything from all over only to beam it back, strained, digested, streamlined.

Its speed gets to me; a whirlwind, it picks me up, pulls me in, and spins me around on its slender, granite-hard body until I lose my head and fall for the city.

Brooklyn Bridge

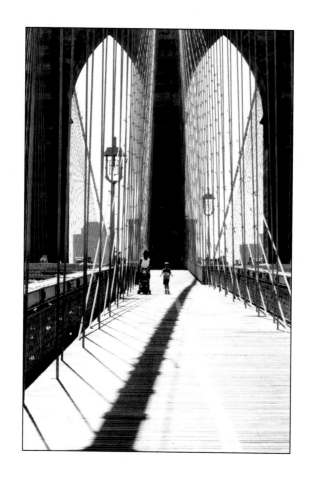

Metropolitan Museum

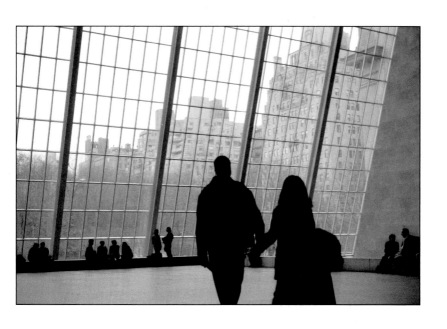

Brooklyn Bridge

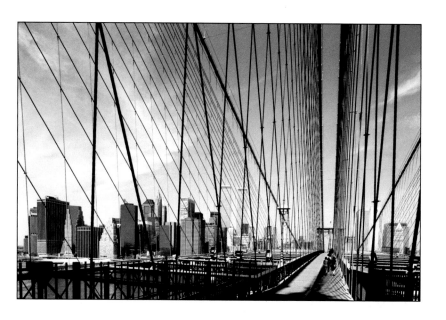

Tudor City

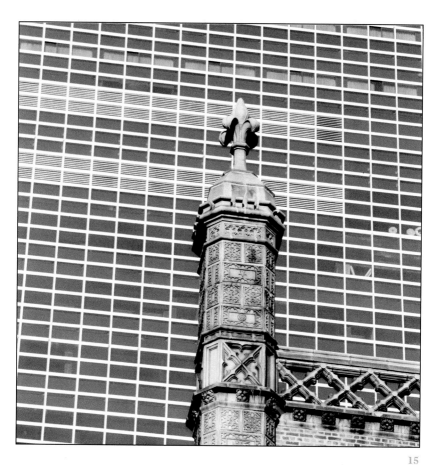

15

Flat Iron Building

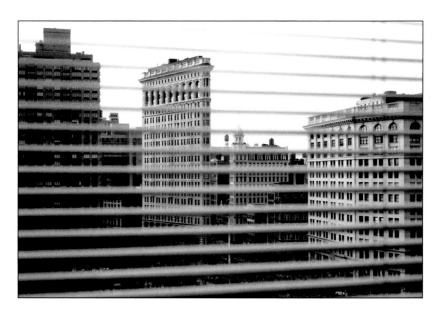

Bryant Park

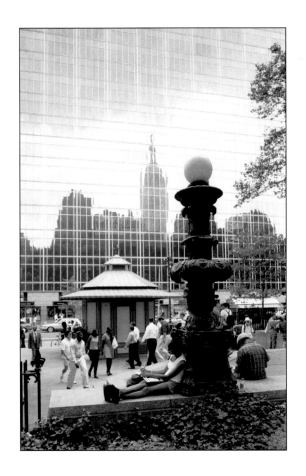

Bistro in Chelsea

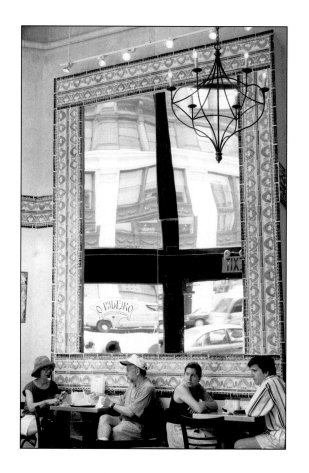

Christy's

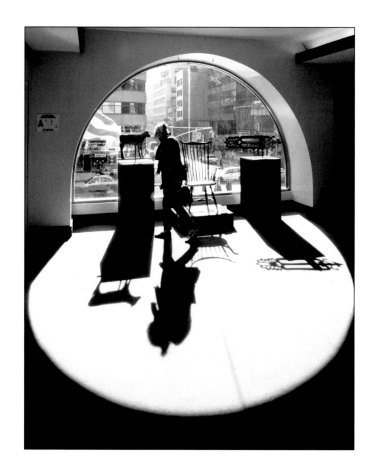

Metropolitan Museum

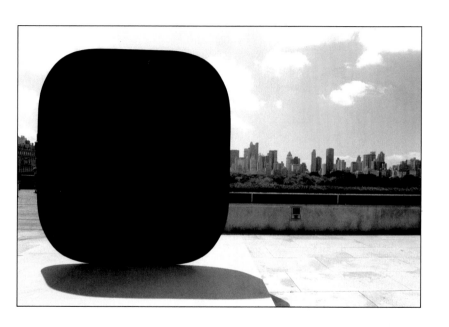

Central Park West

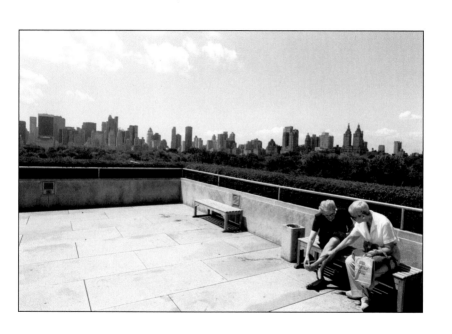

Back massage in Central Park

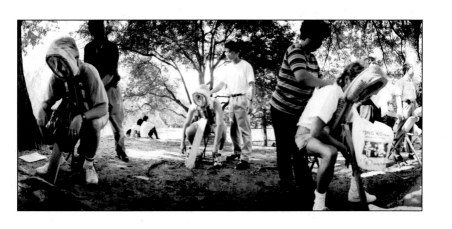

SoHo

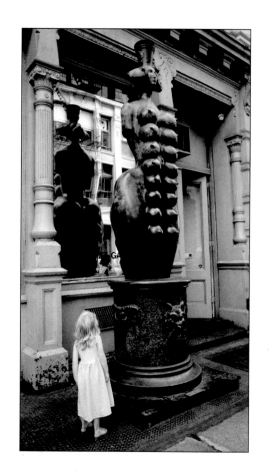

Construction panel

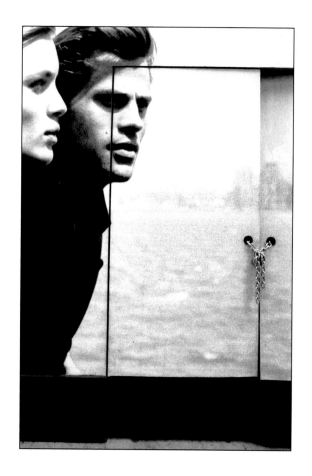

Park Avenue

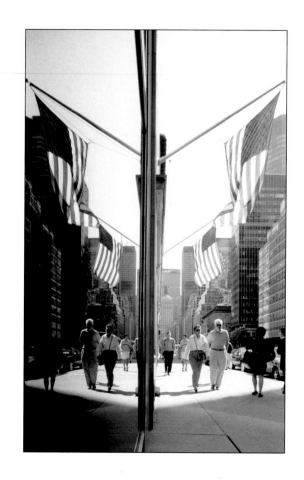

Gramercy Park

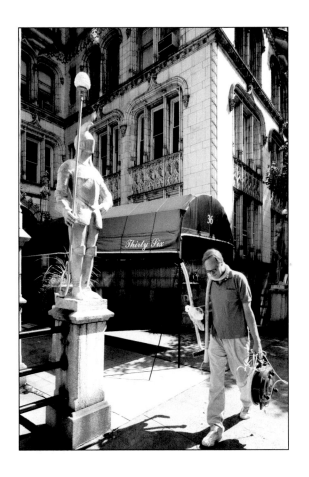

Times Square

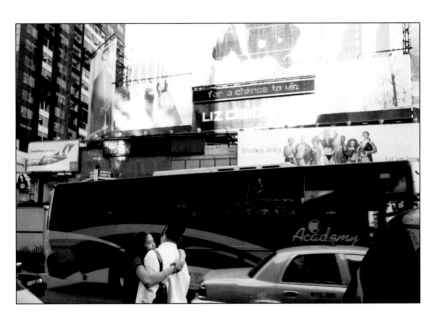

Garment District

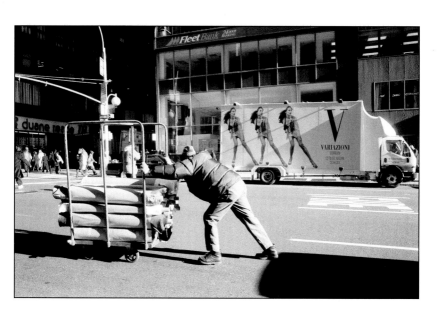

Madison Avenue, midtown

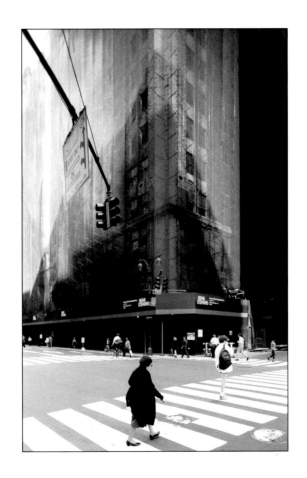

Midtown store window

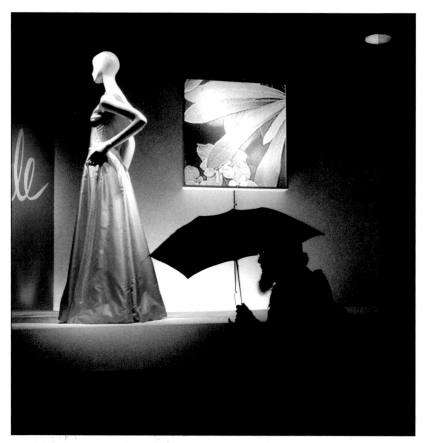

Times Square

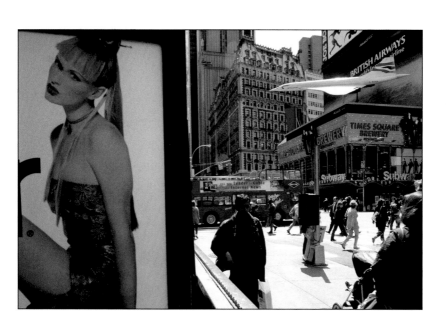

Columbus Circle

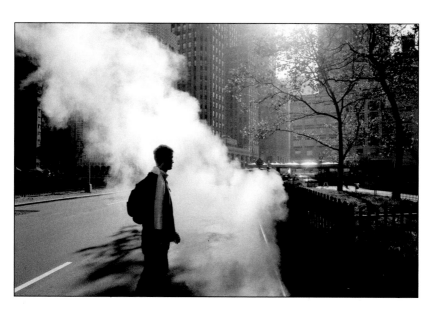

SoHo

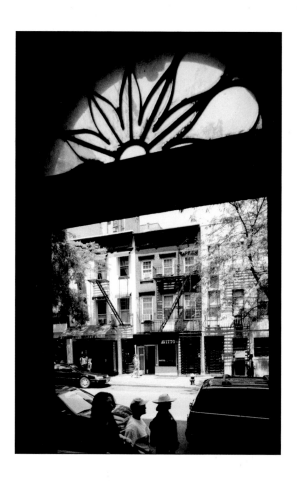

Empire State Building

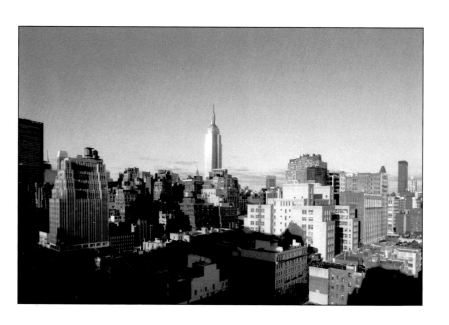

Villard House (Palace Hotel)

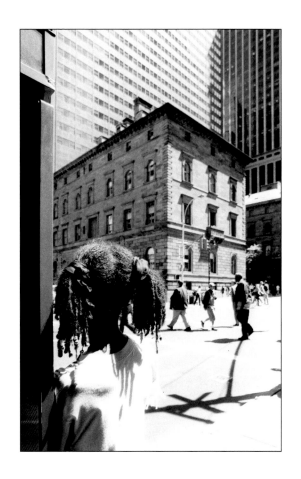

St. Patrick's Parish House

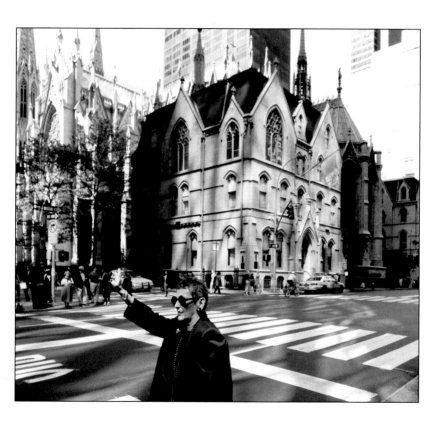

Chelsea

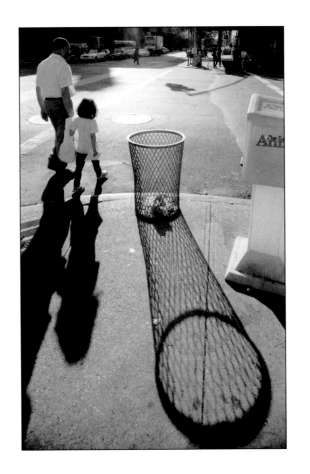

West 57th Street

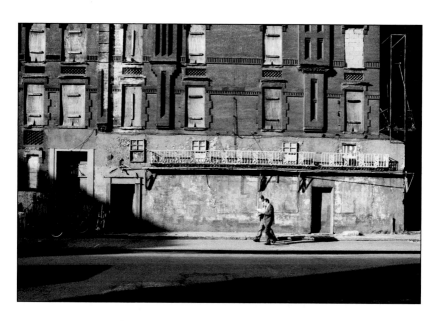

Chelsea

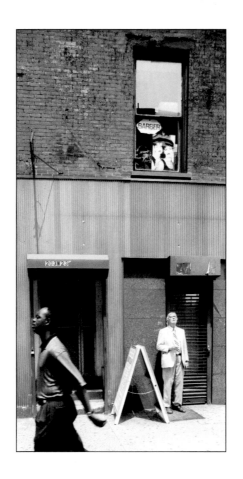

City Corps Plaza

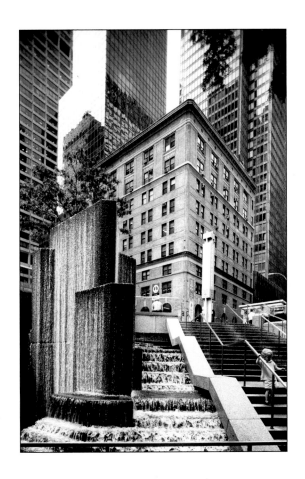

Park Avenue

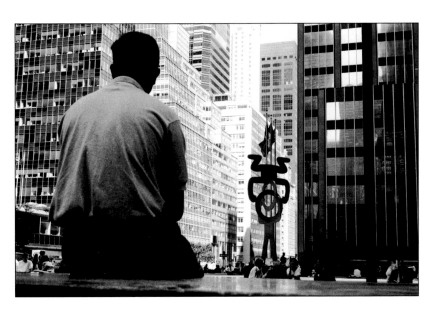

City College overpass

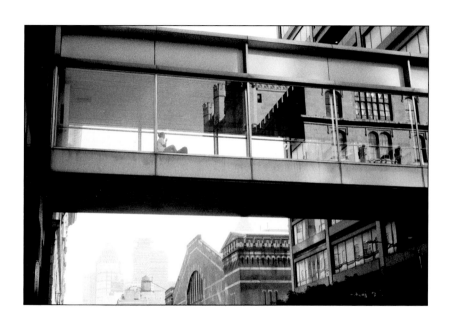

New York Public Library

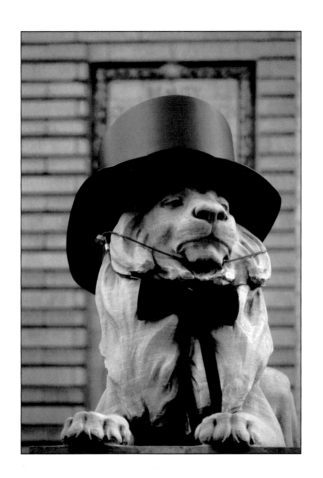

SoHo

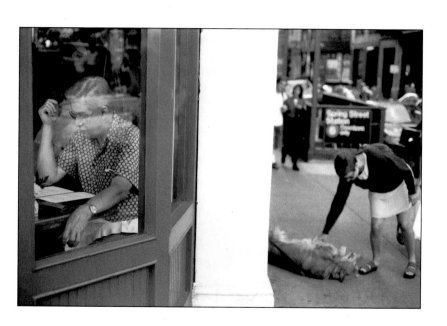

Lower Fifth Avenue

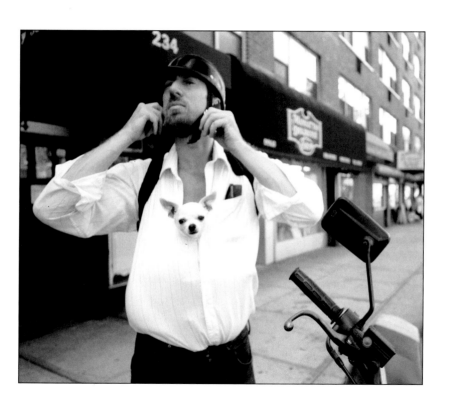

Madison Green

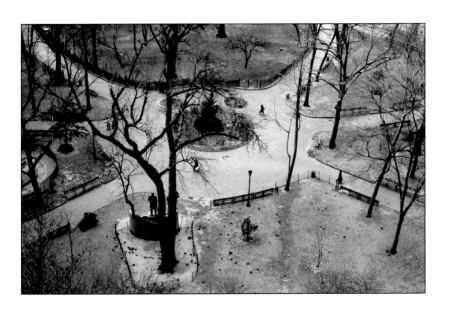

Tudor City

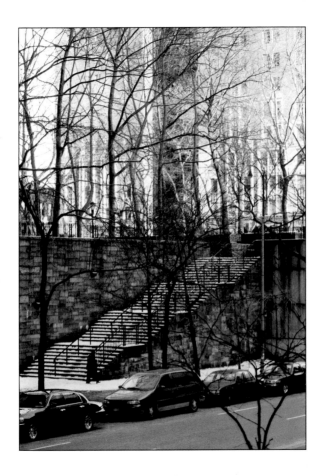

Madison Green

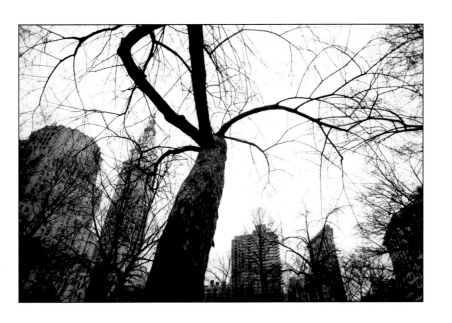

Central Park

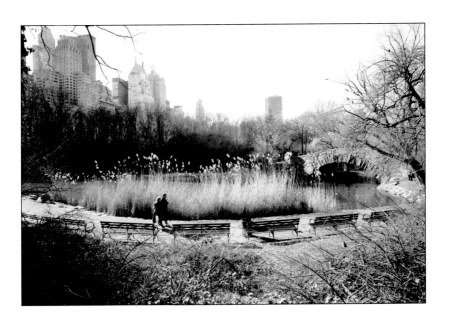

Central Park

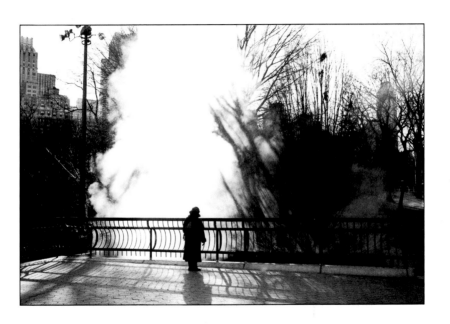

Central Park

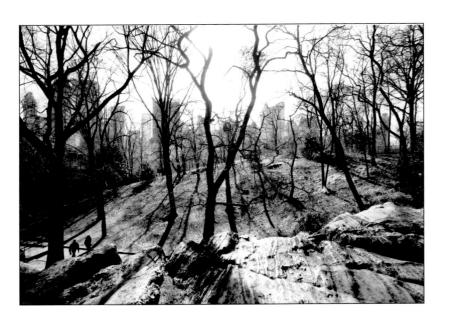

Carl Schutz Park

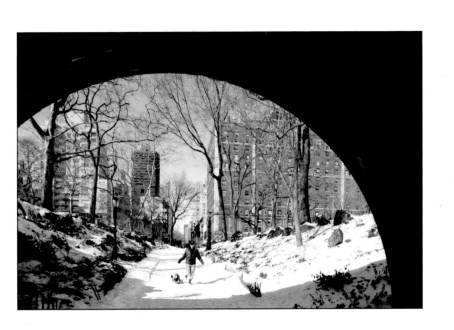

Rockefeller Center

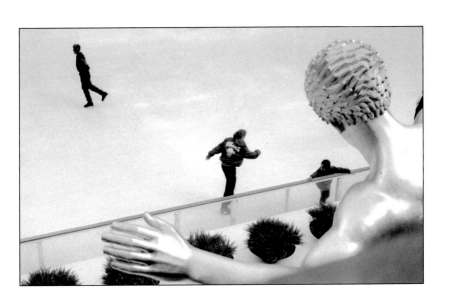

Wallman Memorial, Central Park

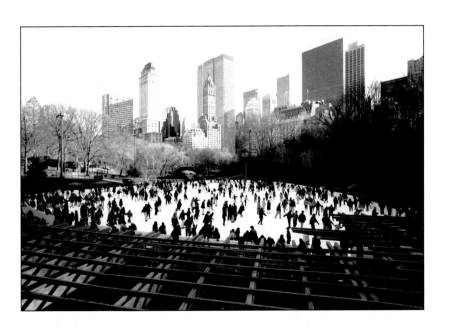

Central Park

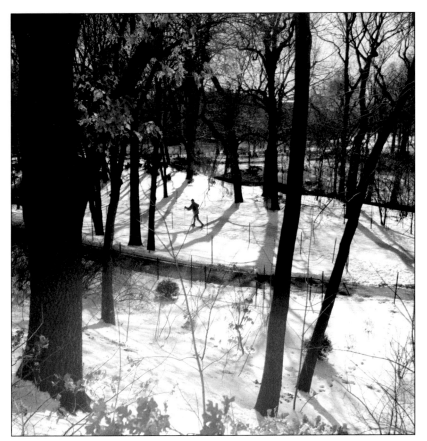

Bryant Park

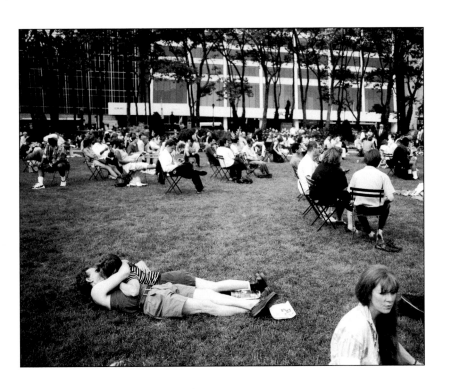

Bryant Park

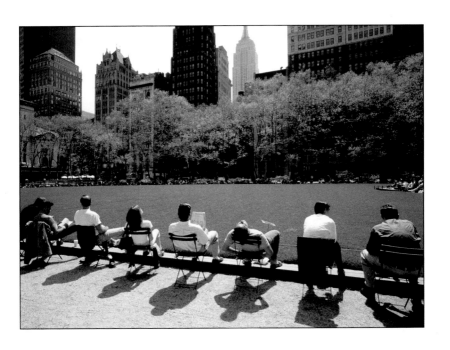

SoHo

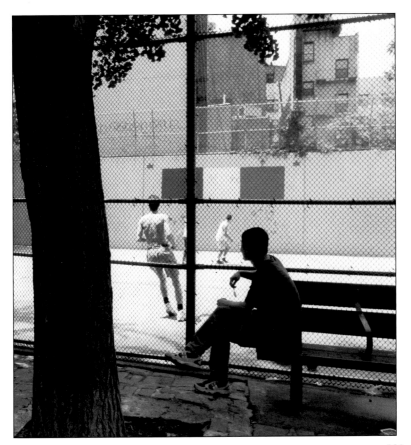

Brooklyn Bridge

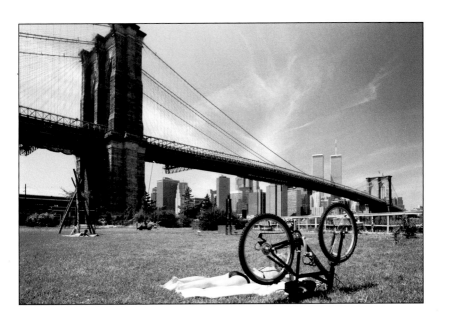

Manhattan from Liberty Park, NJ

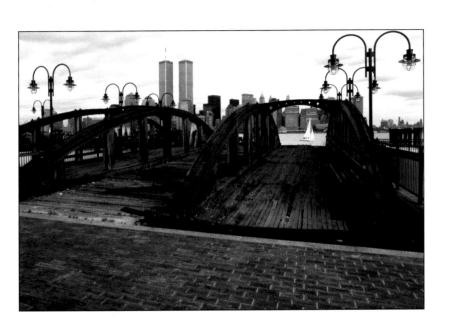

Bryant Park

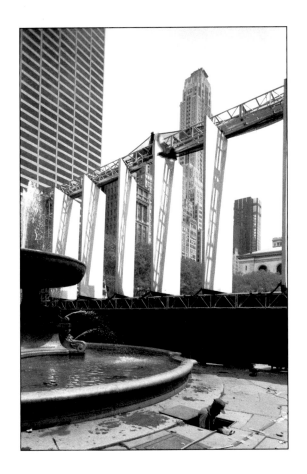

From Washington Square

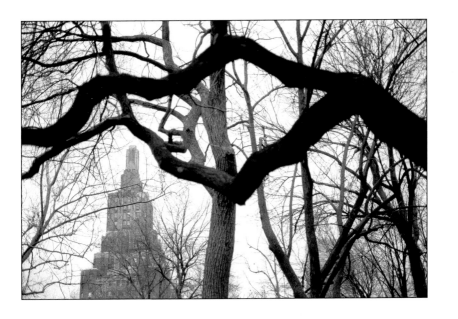

Chrysler Building

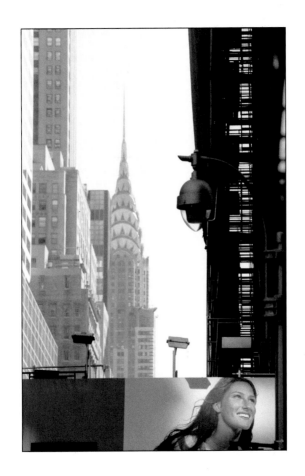

Port Authority

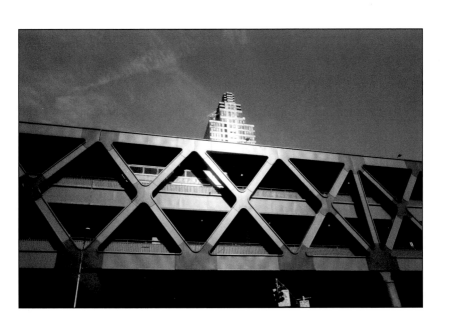

Union Square

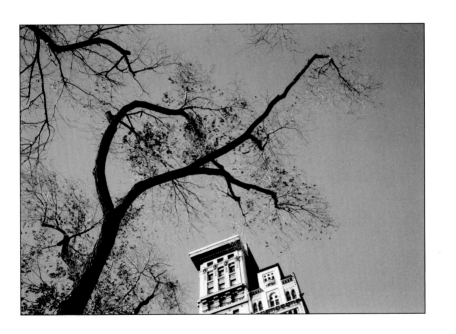

Windows on the World, World Trade Towers

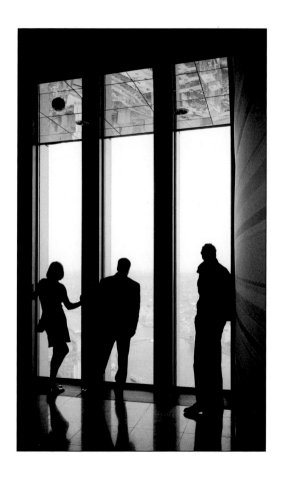

World Trade Towers

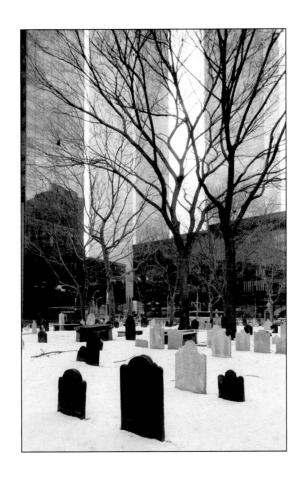

Central Park

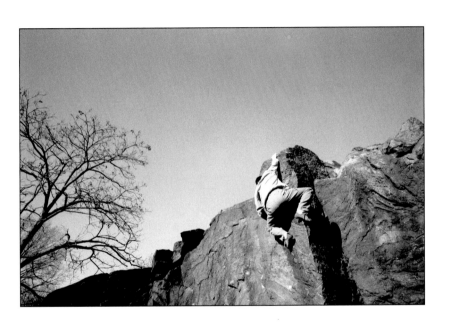

From the Intrepid Museum

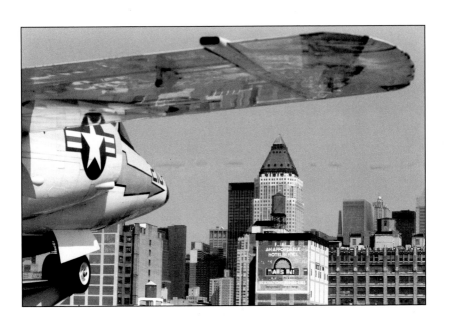

World Trade Towers from Pavonia, NJ

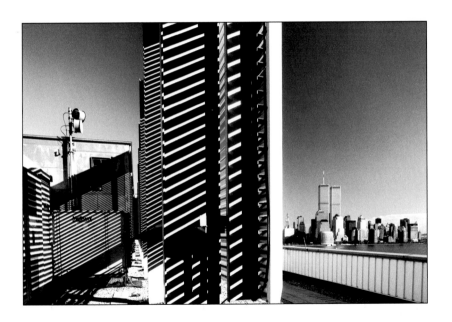

The tower of Riverside Church

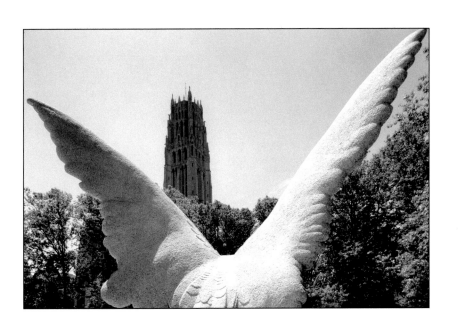

Upper Fifth Avenue

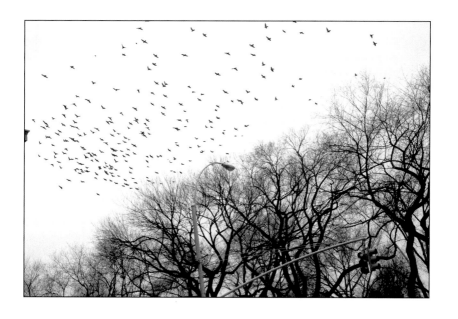

World Trade Towers

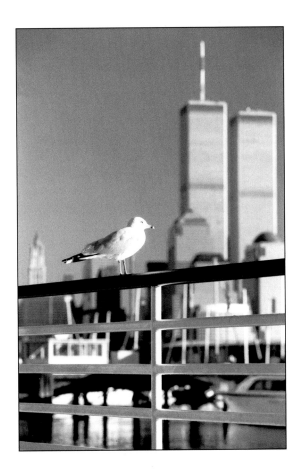

World Trade Towers from Liberty Park, NJ

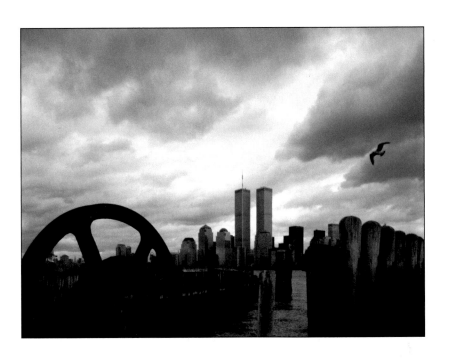

South Street

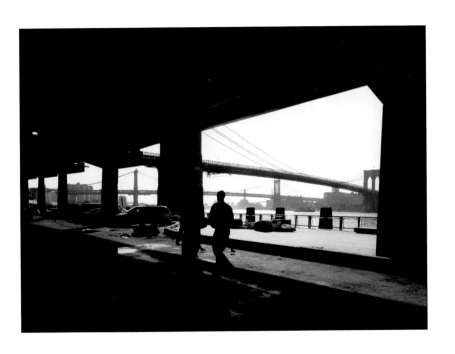

Battery Park

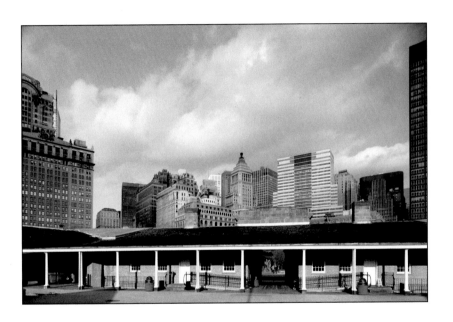

Battery Park

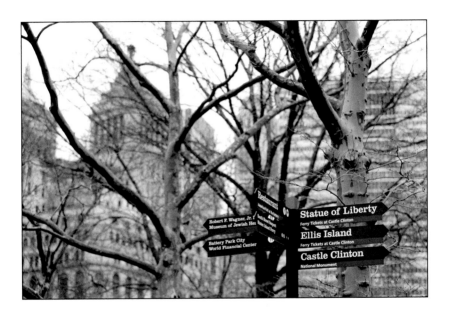

Statue of Liberty

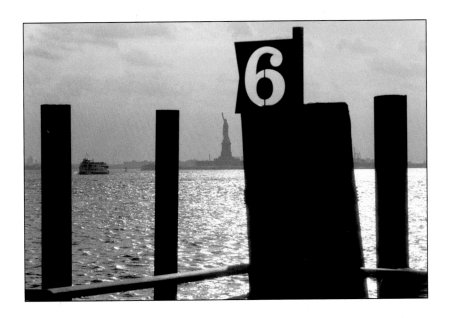

George Washington Bridge

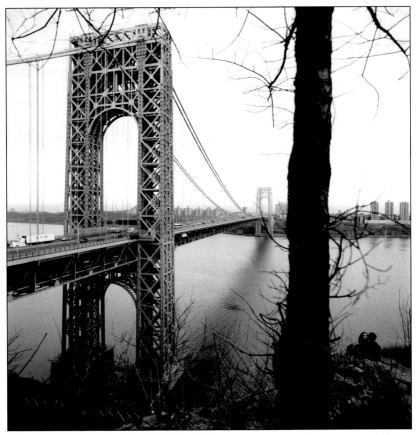

ACKNOWLEDGEMENTS

This book never would have become a reality without my supportive family: Anna, my wife, and our children, Judit and Andras, who came along with me to renew our life in the States, who made me believe that it was worth working on this photo book for three years. Magda Thein deserves my gratitude for sharing her home with us, being our "adopted grandmother" family member here. My special thank's go to Jim Mairs, my editor at W. W. Norton, who was open to a newcomer and helped to create this photo book. Most of the photographs in this book were taken with a Leica M6, with various sharp lenses. The Leica's silence allowed me to get close to the city and the people. I thank Ralph Hagenauer and Doug Eldredge of Leica Camera Inc., USA for supporting this project. I thank Rose and Jay Deutsch of Leica Gallery, New York for their exhibition based on this book.

PHOTO BOOKS BY TAMAS REVESZ PREVIOUSLY PUBLISHED IN HUNGARY

Budapest: A City before the Millenium, Herald 1998

Budapest: A City before the Millenium, Herald 1996

Open Air: the American West, Herald 1993

Siófok (Siofok), Herald 1993

Budai Várnegyed (Castle District of Buda), Officina 1989

Róma (Rome), Corvina 1988

Siófok (Siofok), Inforg 1987

Szicília (Sicily), Képzômûvészeti 1987

Parlament (Parliament), Corvina 1985

Csaba kórházba megy (Csaba Goes to Hospital), Móra 1982

Búcsú a cigányteleptôl (Farewell to Gypsy Colonies), Kossuth 1977